"My Friend, You Are Legally Blind"

"My Friend, You Are Legally Blind"

A Writer's Struggle with

Macular Degeneration

by Charles Champlin

2001 · John Daniel & Company, Santa Barbara

c

Published by John Daniel & Company
A division of Daniel and Daniel, Publishers, Inc.
Post Office Box 21922
Santa Barbara, CA 93121
www.danielpublishing.com

LIBRARY OF CONGRESS CATALOGING-IN-PUBLICATION DATA
Champlin, Charles, (date)
 My friend, you are legally blind : a writer's struggle with macular degeneration /
by Charles Champlin.
 p. cm.
 ISBN 1-880284-48-0 (pbk. : alk paper)
 1. Champlin, Charles, (date). 2. Retinal degeneration—Patients—Biography.
3. Blind aged—Biography. I. Title
 RE661.M3 C48 2001
617.7'35—dc21
 00-012824

For Peggy, again,

because without you this book
could not possibly have been written

Contents

Acknowledgments

¶ I am grateful to my two doctors who have given me guidance and treated me over the years: Dr. Jay Gross and Dr. Thomas Hanscom.

I am grateful as well to the organizations that are so enormously helpful to the partially sighted and the blind here on my home ground of Los Angeles: The Braille Institute with, not least, its superb library of audio books and its information, consultation and educational services; and the Center for the Partially Sighted with its diagnostic and related services.

But the overriding condition of the newly blind or partially sighted is their new and often dismaying feeling of dependence. Living with AMD is a seemingly endless discovery of things small and large you hadn't realized you could no longer do. Driving and reading without massive magnification are obvious. But the list of subsidiary needs is very large, headed in my case by finding things I have misplaced.

I can't imagine surviving a day without the loving and patient help of my wife Peggy. She endures my angry mutterings and occasional bellows of rage at my

own limitations. She is an expert and tireless chauffeur and I am learning not to be a front-seat driver. She is a skillful reader and skimmer of our two daily papers. And...but the kindnesses roll on and there are no words sufficient to convey my love and my gratitude and my awareness of just how lucky I am.

Charles Champlin

Los Angeles, Fall 2000

"My Friend,You Are Legally Blind"

"My Friend, You Are Legally Blind"

¶ There seemed to be smudges of ash, as from a distant fire, falling on the pages of my book. I was sitting in the back yard on a brilliant September afternoon, reading, with the help of a magnifying glass, Humphrey Carpenter's biography of Dennis Potter, the innovative British television writer.

I had become worried because there never seemed to be enough light indoors. It is a symptom of cataracts, but I had had a cataract removed only a few months earlier.

I looked again at the page of my book and realized that I was burning tiny holes in the paper with the magnifying glass and at almost the same moment jerked my left hand away because the glass had started to burn my thumb. I closed the book—forever as it turned out—and went inside and called my ophthalmologist, Dr. Jay Gross, for an appointment as soon as he could see me.

When I saw him a day or two later, he looked over my performance on the eye charts, leaned back in his chair and gazed at me for a moment, then said, "My friend, you are legally blind."

That meant my vision was 20/200. What I could make out at twenty feet, a normally sighted person could see at two hundred feet. Dr. Gross said there were unmistakable signs of swelling and bleeding in my "good" right eye. The cataract he had removed was indeed gone and the lens he had implanted was in place. There was nothing more he could do and he advised me to see my retinal surgeon, Dr. Thomas Hanscom, as soon as possible. Dr. Gross filled out a form attesting to my legal blindness for transmission to the state.

I had started wearing glasses when I was nine and in the third grade. They had thin gold rims and seemed to me the kind of glasses old men wore. I hated them but I had to admit that I could see the blackboard again in Miss May Hamilton's room.

Over the next sixty-plus years I changed styles and prescriptions regularly. The optometrists told me I had one strong eye and one weak eye, one near-sighted, one far-sighted. I could never remember which was which. I was eye-conscious without being eye-worried. Even before I was out of high school I had begun to feel naked without glasses and thought I looked funny bare-faced, yet without my glasses I squinted like a mole and saw very little. When I sailed overseas late in 1944 as an Infantry replacement, I carried a gas mask fitted with prescription lenses. I've forgotten what became of the gas mask. We had all discarded them before we ever hit combat.

My eyes and I got along fine until about ten years ago, when my left eye went to hell. A blind spot suddenly appeared just to the right edge of my central vision—

a kind of gray-black "thing" that looked like an inverted skull or perhaps the scarab that was the symbol of The Phantom in the comic strip.

My ophthalmologist of the time referred me to Dr. Hanscom. Injecting a dye in my veins and then taking pictures of my left eyeball, he discovered some leakage and fired some laser shots, which stopped the leakage. I must say that all the physiology of the trouble is clearer to me now than it was then. And if, at the time, he used the term age-related macular degeneration (AMD), it sailed over my head and I have no memory of it.

The blind spot was permanent and is still with me. The other immediate consequence was that I began to have trouble with depth perception. I kept reaching for things that turned out to be an inch or two east or west of where I thought they were, and if I weren't careful I missed the cup or the glass and dampened many a table-cloth with water, wine, milk, coffee, and any other beverages I had in hand. Occasionally I bumped into things, misjudging a corner or a wall by an inch or two.

The consolation was that my "good" right eye was in fact good, correctable to 20/20 or maybe 20/30 and doing the work of two. Somewhere along the line I had been told that I had an incipient cataract in the right eye not yet operable. Gradually the cataract symptoms became more insistent: the need for ever more illumination on what I was reading, the way I was blinded by the glare of approaching headlights when I was driving at night. Early in 1998, after Dr. Gross removed the cataract, for a few glorious months I saw better than I had in years.

But now, after Dr. Gross's somber tidings, I made my

appointment with Dr. Hanscom and, as he had a decade earlier, he photographed the interior of my eyeball with a technique known as fluorescein angiography. This time, of course, it was the right eye, and his tidings were also somber. The further bad news was that this time he could not use the laser shots to stop further leakage. The leakage was so close to the retina that the shots might well have destroyed the macula, which is that portion of the retina that controls the central vision.

To match the inverted skull I perceive in my left eye, I had acquired a comparable blind spot, circular rather than skull-shaped, just off the center of my right eye.

What was inescapably clear was that I had reached a major and permanent detour from the life I had led for seventy-plus years and now had to begin to explore a new and difficult path.

The Things I Saw

¶ In the mysterious way that career decisions are sometimes made, I decided very early in my life that I wanted to be a writer. Very early, even before I was old enough to join the Boy Scouts. I don't know why. My parents were literate and college-educated, but neither was a writer and there hadn't been a writer in the family on either side going back as far as I could easily trace.

As I wrote in a memoir of my early days, *Back There Where the Past Was* (Syracuse University Press, 1989; 2nd ed. 1999), my family had been in the champagne-making business in Hammondsport, New York, for three generations.

I'd been a hungry reader from the time I could read at all, and reading and writing go hand in hand. I don't remember knowing what kind of writing I wanted to do—story-teller, journalist, essayist. In those earliest days, I only knew I wanted to spend my life putting words together. Undoubtedly it was the line of least resistance. Even at age ten, it was what I did better than anything else. I was incompetent at all sports, afraid of heights, weak-eyed, frail, but verbal and at least somewhat funny.

So I wrote. Mother had a typewriter, full sized, and I wrote letters on it, wrote pompous inquiries for catalogues and requests for autographs. I worked on the high school annuals, mimeographed in those days. I wrote parodies as auxiliary assignments in English. There was never a question that I would major in English at college. In letters home I recorded my career in basic Infantry training in great detail, and I remember writing a rather dramatic letter to my girl friend of the time by candlelight in the cellar of a German farmhouse. I would be curious to read it again, but the woman died years ago and I'm sure she had burned all my letters even before I was out of service.

Still and all, and this is in a sense the story of my life until recent days, my eyes were my particular livelihood. After I went back and finished college, I luckily was taken on as a trainee at *Life* magazine and spent seventeen years as a reporter-correspondent and writer for *Life* and then for *Time* magazine. I covered election campaigns in the Midwest, chasing Estes Kefauver in the Nebraska presidential primary one year. I reported steel strikes and bitter union elections, covered floods along the Missouri and the West Nishnabotna, and a sudden blizzard that trapped elk hunters along the Mogollon Rim road in northern Arizona. From a small plane, I watched a dramatic rescue of an injured climber high up on Mount McKinley. I camped for two weeks on the glorious Colorado plateau country, working with a *Life* photographer. There was much to see, and I saw it all.

For three years I worked for *Time* in Europe and drove to the northern tip of Scotland on a religion story, dined in the ancient colleges of Oxford and Cambridge,

covered several Grand Prix races, and one lovely year reported Scandinavia's beautiful trio of young princesses.

For a dozen years or so, after I left Time, Inc. and joined the *Los Angeles Times*, I was an annual visitor to the Cannes Film Festival, that extraordinary circus of great and ghastly films and the pervasive aromas of costly perfume and cigar smoke beside the sparkling Mediterranean.

Indeed, I came to think of all my early years in journalism as a prologue for my real life's work: being a film critic for the *Los Angeles Times*. My years as a correspondent were invaluable because the movies, or some of the best of them, reflected the real world and I could measure them against the reality I remembered. More than that, I had, in a cliche phrase, come to know people from all walks of life, from Window Rock to Wall Street, and among them all, even a murderer or two.

I came to movie reviewing after a lifelong love that began at the Park Theater in Hammondsport when I was five. I found that I had chosen a revolutionary time in the history of American movies to start reviewing. At the end of the 1960s a new rating system gave American movies a creative freedom and technical fluency they had never enjoyed before. The worst of the movies were more colorfully exploitive than they had ever been, but the best of the movies had an emotional density and a thematic expanse they had also never had before. Television never had quite the same interest or excitement for me, and yet I see now that I had witnessed the medium's golden age, the dramatic glories of "Playhouse 90" and the weekly hour dramas on such shows as the "U.S. Steel Hour," the fine series like "M*A*S*H," the

documentaries, the revues from Uncle Miltie to Carol Burnett and Dinah Shore and Sid Caesar.

In twenty-five years at the *Los Angeles Times* as arts editor, film critic for thirteen years, and columnist, usually three times a week, I wrote close to three million words and I think many of them weren't too bad.

What remains to be said is that, unlike many a childhood vision of a life's work, mine had come true. I could not have said at ten or twelve that I would end up with a career in weekly and then daily journalism, nor as a critic and essayist whose newspaper, the *Los Angeles Times*, allowed me an unparalleled freedom of subject matter. I came, I saw, and I was hugely grateful for the chance to exercise the gift of words I had inexplicably been granted.

And then, on a September day in 1999, the glories of sight were swiftly, as it seemed, and devastatingly curtailed. I had blessedly not become blind-blind, but a certain mobility had been taken from me.

I see the riches of my visual past, but now in the mind's eye, where the scenes and faces are thankfully as vivid as ever. The faces long gone, mother, grandmother, maiden aunts, friends beyond counting, appear in quiet moments. And the great consolation is that the gift of writing stays with me.

The End to Driving

¶ Looking back, I realize that macular degeneration had been creeping up on me, stalking me as it were. There was no blackout, not even a momentary flicker. The vision in my "good" right eye was doing a slow fade. There had been warnings even before the incident with the magnifying glass in the back yard, which left me no choice but to seek help fast.

One afternoon, driving down steep Roscomare Road near our house, a two-lane road often with cars parked on both sides, my wing mirror clipped the wing mirror on a parked car. It was my loused-up depth perception that created that trouble, which was more embarrassing than anything else. I paid for the two broken wing mirrors and that was that. I steered clear of parked vehicles thereafter.

A few days later I elected to drive Peg to the hospital in Pasadena to see our newest grandson. Late afternoon is tricky at best, long shadows and failing light, and the lane markings on the Pasadena Freeway are faint. Cars were whizzing past me on both sides. My knuckles were white on the steering wheel and my armpits were prickly

with nervous perspiration. I got us to the hospital safely, but once we were parked I handed Peg the keys and knew that I did not dare to drive again.

It was after the nightmarish drive to Pasadena that the strongest operational impact of AMD hit me. We live in the most heavily automotive society that ever was, and in Los Angeles, the city that in its sprawl toward open land reflects more than any other the influence of the car.

Our street is on the crest of a hill. The nearest metropolitan cluster is four miles south and downhill to the Los Angeles basin, and four miles north and down hill to the San Fernando Valley. There is a neighborhood shopping center within walking distance (a quarter-mile away), with a medium-sized market, cleaners, beauty shop, a mailing center, and a struggling pizza shop. But no bank, furniture store, clothing outlet, full-menu restaurant, shoe store, cinema, and so on. A video cassette shop opened but did not survive. I should add that there is no bus service and it's a twelve-dollar cab ride to the nearest frequented destinations. The car ceases to be a luxury.

Ah, the car.

In our blissful pre-AMD days, we had three automobiles. My wife's four-door Dodge Shadow was eight years old, my Ford Escort was six years old, and my cherished 1970 Mercedes 280SL convertible, which I bought with my advance for one of my books, was thirty years old. In recent years the Mercedes had mostly been sitting in the garage, seeming almost too precious to drive. Alas, it had suddenly become obvious that we had two cars too many.

One morning Peg and I drove the Mercedes to the garage where it had been serviced for the twenty-seven years I had owned it, and Wolfgang, the proprietor, agreed to sell it on consignment for me. It was a haunting presence in our garage and, as with any death, I felt the need of closure. My feeling was that Wolfgang might be able to find a buyer who would regard the convertible with the same affection I had had for it.

Being unable to drive is not the biggest penalty of AMD; being unable to read without magnification is. But not driving does raise hob with the life that once you led. For all my half-century in journalism and even now in retirement, lunch was a social ritual that was also a battery charge for renewal of news, information, gossip and the nurturing of often long-established friendships.

In my working days as a magazine and newspaper writer, I had lunch "out" as many as five days a week. I never kept count of the interview lunches I conducted at the grand old Brown Derby on Vine Street, at Musso & Frank over on Hollywood Boulevard, at the smoke-filled Redwood Restaurant a few doors from the Los Angeles Times and, depending on the grandeur of the interviewee, in the Polo Lounge or on the terrace at the Beverly Hills Hotel.

All that, of course, has come to a shuddering halt. Peg drives me to lunch or I take cabs; occasionally friends pick me up and deliver me home. But those grand lunches have dwindled to one or two a week. The old lament of wives that "I married you for better or for worse but not for lunch" is relevant here, although Peg has not complained.

But it remains true that one of the consequences of macular degeneration is a kind of reconstruction of one's life, an enforced re-centering on life at home. The Michelin guides differentiate views they say are worth seeing from views that are worth going out of your way to see. In something of the same spirit I find I ask myself whether an event I might have once driven to attend is now worth being driven to. Cocktail parties often fail the test. And yet for all the problems of diminished sight I find that there are a sufficiency of plays, films, art exhibitions, and lectures that I am still eager to attend.

Sometimes, riding shotgun beside Peggy as my indefatigable and very expert driver, I recall an anecdote from the days when I was an occasional luncheon guest at the Lakeside Country Club. One of the members had car trouble and needed an immediate lift to Hollywood. The doorman said another member was going that way and would be glad to drive the stranded golfer to Hollywood in his new Rolls-Royce, of which he was very proud.

As the two men drove toward Hollywood the driver said, "I'll bet you've never ridden in a Rolls before."

"Not in the front seat," the passenger said.

That, in a literal sense, was one of the things I've had to get used to: being the perennial passenger, no longer ever at the wheel. It has taken a little while learning not to be a front-seat driver. On long drives, Peg always suggests I rack the seat back and snooze. No way. Peg never gives me cause for alarm, but she is also too polite to curse at the stupidity and folly of other drivers, and I am still good at that. I suppose it is a way of preserving a small corner of independence in my new age of dependence.

There remained two or three traumas to be got through. One day we called the American Red Cross and offered up the Dodge Shadow as an automotive sacrifice, which the Red Cross accepted with unconcealed gratitude.

Then Wolfgang, of the German repair shop, reported that there was a young woman eager to buy my much-treasured baby blue Mercedes. One rain-drenched Monday morning, the new owner appeared with a cashier's check and all the necessary documents in tow, and I said good-bye to the beloved Mercedes. But we Mercedes owners understand one another and she said consolingly that of course I had permanent visitation rights to what was now her car.

As we were five decades ago, we are once again a one-car family.

Where Am I?

¶ One morning, early in my struggle with AMD, I looked in the mirror as I was getting ready to shave and realized I wasn't there. I could make out a vague silhouette, but it was as if I were an updated version of the Headless Horseman of Sleepy Hollow. The effect was like one of those fairground cut-outs, in which a teenage girl can poke her head through a hole where a Mona Lisa's face was, or a couple can become Grant Wood's "American Gothic."

Learning to acclimate to AMD is a series of discoveries large and small. Being unable to drive or read without the help of a magnifying machine are the biggies, of course, but the small ones are the botherations of daily life.

At first I had a terrible time trying to put the toothpaste on a brush I couldn't see. Soon enough, I learned to squeeze the toothpaste on my index finger, apply it to my front teeth and march on from there. A silly and I'm sure easily obvious idea, but I had to discover it.

Parting my hair is such sweet sorrow. I brush my hair forward, then pull the short side down left and the long

side over the crown to the right and hope I've got it about correct, testing with my fingers for stray locks and asking my wife if it's generally okay.

I've been making beer bread for many years. That's bread using self-rising flour and a bottle of beer, no kneading or waiting required. I started a loaf one day, when it dawned on me that I couldn't see to set the oven temperature or turn the oven on to the right notch.

Buttering bread and rolls is a very tricky business, and I haven't learned the trick. I either get too much spread or none, since both butter and margarine tend to be the color of china and there is no color contrast to help you. My wife now does the buttering for me, very surreptitiously in restaurants. I prefer restaurants that serve olive oil instead of butter.

The labels on medicine bottles are hopeless. We have discovered those seven-compartment plastic pill-holders and my wife fills two a day, one for morning, one for night.

One of the benefits of the forms Dr. Gross filled out was a special telephone supplied free by GTE. Its keys are an inch square and the numbers nearly that large. I still manage to misdial perhaps one time in four or five, but my luck on ordinary handsets is far worse. One night on a wall phone I hit what I thought was the memory button and a man answered. I hung up quickly and an hour later two policemen came to the door asking if everything was under control. I had hit an emergency number. I apologized profusely and would gladly have throttled the nearest industrial designer. Every handset seems to have a different arrangement of

keys. Just as bad are remote control gadgets and the knobs on radios, stereos, and other wicked instruments, all designed for those with eagle eyes. Becoming legally blind requires an investment in new, specially designed gadgetry.

Legal blindness, or partial sightedness, take your pick, is a curious state, possibly the more frustrating because you are not, mercifully, totally blind. What you can't see, or do, is far short of tragic, but it has its frustrations.

What I can't see is close up, like my disappearing face in the mirror. I can't see my fingertips, for example, and even had a couple of professional manicures until embarrassment drove me out of the neighborhood beauty parlor to live dangerously with nail clippers. Even a magnifying glass is no longer a help with post cards, medicine vials or phone numbers.

I can't quite make out my watch, even with its fairly large numbers. There are simply no details close up. Beyond a few feet, I see the world, the lawn and the vistas beyond. Mostly I don't have trouble with stairs or steps. But even the world I do see is seen through a faint haze, as if through a theatrical scrim. I can see street signs but not read them, and even billboards are often incomprehensible. Those blind spots in both eyes are curious. Paused the other day at a red light, I watched cars entering the intersection. In mid-street they seemed suddenly to disappear, only to reappear on the far side. It was almost eerie, because the road above and below the spot remained visible. It was like a photographic trick.

When my wife and I take an evening walk up our road, I hear cars approaching from either direction

before I can see them, and they loom into sight perhaps two or three car lengths from me, obscured by the blind spots.

The dents in my central vision, so to speak, have made me more reliant on my peripheral vision. I discovered that I have to look at movies and television in sidelong glances, peeking at them from the corner of my eye. I do see the images in color that way, although I can rarely make out the words. But what I see when I look directly at the screen often approaches the bizarre. Television images tend to be masses of mottled gray and black shapes, like a cold lava flow; movies are just incomprehensible.

There is nothing like AMD to provide fresh sources of genuine gratitude. It is as well, of course, that my days as a practicing film critic and media commentator generally are behind me. I can make do with memory. I also gratefully thank my stars that I took touch-typing my sophomore year in high school. It served me supremely well through fifty years in journalism. It serves me now because I can still write on the computer, unable to see what I'm writing, but doing it well enough so that the proofreading is not too onerous a chore for my wife.

In an earlier book, I paraphrased a passage from Christopher Isherwood's *Down There on a Visit*, in which he said, "Who am I but a daily succession of statements to a mirror that I am I?"

I am still I; it is just that neither I nor the mirror can see me.

A Pleasure Imperilled

¶ I suppose the very first thing that hits you after AMD has done its work is that you won't be able to drive.

The second impact of AMD arrives like the latter half of a one-two punch. It is a little subtler. A fraction slower to arrive, but it is longer lasting and far more oppressive. Not being able to read, or read without difficulty, is grim to contemplate for anyone whose whole life, including his entire professional life, has been inextricably bound up with reading and writing.

Just as I can't remember learning how to read, I can't remember a time when I couldn't read. I only know that my love of words and the printed page had been with me seemingly forever.

The small public library in what had been a storefront in Hammondsport had no children's corner as the present library does, only two or three low shelves for children's books. I worked my way through those shelves at high speed: all those cute animals who walked erect and wore kiddie clothing, all the fairy tales and adventurous real-life kids, leading to Tom Swift and his innumerable exploits.

By the time I was ten, I knew I wanted to be a writer, as unrealistic as that was. It was probably in part because I already knew I would never make it as a shortstop, a doctor or a pilot. More probably it was simply because I wanted to create books like those I enjoyed, just as George Lucas and Steven Spielberg have both said they wanted to make films like those they loved at Saturday matinees.

A little later I peddled magazines and read *The Saturday Evening Post* from cover to cover, including the deep sea fishing stories by Philip Wylie and the romantic serials by Clarence Budington Kelland. One summer I peddled newspapers to cottages along the lake and I read *The Corning Leader*, the *Elmira Advertiser* and the Rochester *Democrat and Chronicle* because there were always unsold copies left over. (It was the most inefficient paper route ever devised, averaging a sale every half-mile if I was lucky.)

I joined the Book-of-the-Month Club when I was fourteen so I could buy a copy of *For Whom the Bell Tolls*, there being no bookstore within thirty miles. I was hooked, and never unhooked. I had *The New Yorker* saved for me at the local pharmacy, which carried the magazines in Hammondsport. I had the notion, unsupported by any evidence of talent, that I wanted to be a cartoonist and the best cartoons were in *The New Yorker*. I even took a correspondence course in cartooning and flunked myself out of it. By then, while I still loved the magazine's cartoons, I had grown wedded to the magazine's text: "Notes and Comment" by Wolcott Gibbs and others, the profiles, and the dazzling short stories by John O'Hara, John Cheever, Irwin Shaw, and many other

writers. I had begun to appreciate the joy of parody, anecdote, and reminiscence as well as information.

During my brief and unmemorable three months as a combat infantryman in Germany in the waning weeks of World War II, I carried two paperbacks in my pack, an anthology of verse and a copy of Somerset Maugham's *Of Human Bondage*.

Looking back, a career as a writer and journalist seems even more inevitable than it was. But a half-century later, I was a retired author, still writing. I had written millions of words, mostly journalistic articles. One day I had lunch with Bosley Crowther, the retired film critic of *The New York Times*. "Charles," he said fervently, "write books; it's all they remember." By the accidents of career, I have since written mostly books.

And then AMD encountered me, or vice-versa. It is remarkable how swiftly the consequences of AMD made themselves felt. One afternoon I could still, with some difficulty and the help of a magnifying glass, read a book. Within a couple of days, I could decipher only the tallest headlines in the *Los Angles Times* and *The New York Times*. The text in books had dissolved into a gray mass and even the magnifying glass could not fetch the words into focus. It was as if a translucent screen had descended perhaps four or five feet in front of me, obscuring the details in what I could see.

But the thirst for words acquired and sustained over nearly seventy years can't be ignored. The question has been how to assuage it.

Even in better days, I had grown addicted to recorded books and on my daily commute to the newspaper I listened to *Madame Bovary*, volumes of Dickens and

Trollope, and much of Larry McMurtry's oeuvre, commencing with Lonesome Dove. I am now more than ever a thirsty consumer of the catalog of two commercial recorded book companies.

But in addition I also have access to the magnificent library of more than 70,000 recordings from the Library of Congress, made available in Los Angeles through the Braille Institute. The Institute also supplies free of charge a special tape player about the size of a portable typewriter. Thanks to those tapes I at last made the acquaintance of Dostoevsky's Crime and Punishment, in a superb reading made in the fifties by the late Alexander Scourby. More recently, I have been making my patient way through Will Durant's The Reformation, a thousand pages long, spanning thirty-six cassettes; Anthony Powell's twelve-novel sequence A Dance to the Music of Time; and Scott Fitzgerald's The Great Gatsby.

Among her countless helps to me, my wife Peggy is a wonderful reader and she lets me hear just-published titles or the occasional curiosity which has somehow escaped the notice of the commercial companies. She skims the two papers each morning, bringing to my attention what she thinks will interest me. It is probably a function of age, but my first interest is not the breaking news, but is the obituaries, which appear in the Metro section of the Los Angeles Times and in either the main news or business sections of The New York Times. As George Burns used to say, he read the obituaries in bed, and if his own name was not among them, he got up and shaved.

Peg sorts my mail and reads the letters I can't. She also briefs me on the magazines that still arrive in

quantity. She is, by profession, a librarian and historian, and she does a lot of research on behalf of the writing I still do.

But listening, invaluable as it is, is still not the same as reading, and my first priority in coping with AMD was seeking a way to be able to read. The answer took the form of a magnifying machine, which consists of a video camera that reads what is on a movable platen and transmits it to a television monitor, the information enlarged as much as fifty-five times. The device, including the monitor, costs about three thousand dollars. It has frustrations and limitations. It is virtually impossible to read a book in the machine, because it is well-nigh impossible to keep the type in focus. Reading a newspaper is as tricky as trying to read a paper while standing in an overcrowded subway car. On the machine as on the subway you keep folding and re-folding the pages, because you can fit only a few square inches of the text on to the monitor screen. Unfortunately, the camera does not pick up hand-written text very well, and I have to give those letters to Peg to read to me. The strong light that illuminates the material creates a glare on coated magazine paper, and it is defeatingly tiresome to try to get through *The New Yorker* in the machine. On the other hand, the magnifier does give you access to typed text, and for that the partially sighted person has every reason to be grateful.

The trouble with the difficulties of reading a newspaper is that it grows all too easy to say "Skip it," because the difficulties of reading the paper become an acid test of interest and importance to me. Yet I don't ever finally surrender the paper to the recycling bin without an uneasy feeling that there is probably a lot of stuff going in

the bin that I should have read, and would have enjoyed reading.

Yet there is another kind of loss, other than importance or urgency, in reading the paper. Somewhere along about high school days I discovered the qualities of style, wit and opinion that are the enduring rewards of reading a newspaper, as of magazines and books as well, of course. I sometimes think that these qualities are in diminishing supply in daily papers. Red Smith and Jim Murray have departed, taking literary grace from the sports pages, and leaving few heirs with anything like their benign but critical gazes.

Reading and writing are closely joined, of course, and as I've said before, I am enormously thankful for being an expert typist. It served me well during fifty years of deadline journalism. It now lets me use the computer to write words I can't see. I can make out when I've hit all caps by mistake and have been, in effect, shouting for a few lines or paragraphs. Occasionally, squinting, I can see that I've hit the wrong home keys, despite the identifying pieces of tape we've put on the "f" and the "j." Once in a while Peg can decipher what I meant to say; more often I just have to try to remember, and recreate.

Then again, life with AMD is a constant matter of accommodations, involving almost everything about your daily existence. Acceptance is all, echoing Shakespeare's dictum that ripeness is all.

The particular and peculiar delights of reading are impossible to recapture intact, but they can remain central in your life.

The Devil of Discontent

¶ One of my first moves after the onset of AMD was a visit to the Braille Institute, essential for anyone with low vision problems. My second visit was to the Center for the Partially Sighted, a non-profit group in West Los Angeles. The Center has an excellent reputation for helping patients make the most of such sight as they still have.

Part of my introductory visit was a long interview with a thoughtful young social worker. She asked me many questions about depression. Was I depressed? Did I have to fight depression? She asked the same basic questions in different guises, almost as if they were trick questions and this was one of those devious police interrogations.

Now I understand more with each passing day why she asked all those questions about depression and despair. She was seeking to learn if I had experienced the subtle and corrosive forces that partial blindness can evoke and whether I had encountered the insistent realization that you are indeed legally blind, and that nothing is about to change. My questioner was obviously all

too familiar with the whole syndrome of despair that can result from the arrival of partial blindness.

I suppose that at first I was in a particular kind of denial. It wasn't that I wasn't afflicted, it was that I was sure I could handle it. I shrugged off the social worker's questions with a show of resistance to the questions as being irrelevant, in my case anyway. I assured her confidently that I could cope with my new limitations— aware, as I thought I was, what those limitations were.

The truth is that I think I have coped with my new handicap fairly well. Thanks to my touch typing, I can still write, and I remember what James Thurber said when he lost the sight of his good eye, the other having been hit by an arrow shot by his kid brother when they were children. Thurber said he didn't mind not being able to draw his lumpy dogs and people, but that if he couldn't write, he would suffocate.

What I find is that there is a cruel delusion in being, indeed, partially sighted. I dream as if I were still fully sighted, a psychological truth that is probably worth studying. Perhaps because of my dreams, I awake each morning imagining for one brief, very brief, moment that my full sight has returned. It hasn't of course, and there are still all the situations that I have to deal with (again, or for the first time).

The repetitiveness of the small frustrations grows more abrasive. We have hundreds of books in the house, legacies of a lifetime of reading and reviewing, and I still from time to time instinctively pull a book from a shelf only to realize of course that I can't read it. My reaction each time is an instant of considerable depression. The phone book does not work in the magnifying

machine; an illuminating hand magnifier is more help, although my peculiar blind spots in my central vision make it almost impossible to read the last four digits of a number. If I steal a peripheral look at the digits, I may or may not get them right. I make notes of numbers and addresses and names, and find that I can't read my own scrawls.

Generally speaking, my faulty vision is not a danger to me. But one afternoon, trying to make myself a cup of instant mocha, I held the cup in my left hand at eye level and then raised the steaming teakettle to it. I managed to pour hot water on my hand. It was very painful indeed but I was not really injured, I was only infuriated by my own stupidity.

I don't have trouble with steps up or down, although I find myself stumbling occasionally on irregularities in the sidewalk. So far I have avoided a tumble.

Most of the time I am sensible enough to recognize the frustrations and accept them and keep calm. At other times I lose my cool, invoke the Deity and lesser figures and terms and storm around the house for a bit. But beyond the lesser frustrations is the more shadowy specter of depression itself, the feeling of being in a nightmare from which there is no awakening. I console myself with the hard truth that I am truly only partially unsighted and can watch a Pacific sunset. I have persuaded myself out of depression at least for a moment. But as I think the social worker knew from her experience with many other patients, the depression does not vanish, it only recedes.

I suppose that at the heart of one's feelings of depression is the awareness, ever present and inescapable, that

you are no longer the independent figure you were before. You are dependent—most particularly on your wife, who has suddenly added the duties of full-time chauffeur, stenographer, reader, guide to all the functions you had before. But you are not dependent only on your wife. You are dependent, as the Blanche DuBois character says in "Streetcar Named Desire," on the kindness of strangers. These are the nice people who steer you to the correct lavatory, airline terminal, or destinations generally. They help you across the street, or at least agree that the coast is clear. Emotionally, this is hard-going, a fundamental shift from one mode of existence to quite another.

One day my brother Joe, a Catholic priest based in Syracuse, came out to see us and gathered the whole family together: our six children and most of our grandchildren, and sons- and daughters-in-law. Joe conducted a brief prayer reading and then invited each of the family members to come forward for a kind of laying on of hands, touching my head and saying a silent or barely audible prayer. I am not sure what this gathering achieved in a specifically curative sense, and yet, it was a deeply moving experience and did as much as anything on earth could to combat whatever depression I might have been feeling. And even now, months later, I find that that moment of togetherness reaffirms me when the going gets rough. Wherever one stands theologically, I commend you to the warmth and support of family and friends. Drugstores and saloons have no comparable tonics to offer.

Despite all the kind and generous help of family, friends, and total strangers, there remains the subtle

difficulty in the life of a partially sighted individual. What happens as a consequence of the limitations of vision is that I find that I am forced into a sort of immobility. I can no longer sit and read a book but I can, of course, sit and listen to books by the hour, and I do. As good as the readings often are, though, I find I have to fight a tendency to fall asleep after a couple of chapters. Not least, this is because inefficient eyes have to work harder than normal eyes. They tire and ache and it is a relief to close them and shut out the blurring world. Drowsiness follows. At the same time I find that I can't do marathon stretches at the magnifying machine or at the computer, and in fact I do most of my typing with my eyes closed, which is why I get those paragraphs in all caps from time to time, or create an impenetrable code by landing on the wrong home keys.

I make it a point to do physical things, sweeping, leaf raking, dishwashing, anything to fight immobility with the mobile things I can still do (no longer including painting or do-it-yourself projects, for example).

Invitations to screenings still arrive, and occasionally something comes along that I know I should see even in sidelong glances, staring just east or west of the screen itself. I listen to more television than I can watch, you might say. To see what's on the screen, I look just off the set. I miss the movies more than I miss television, but take the problems with each medium as part of my new day, which I do learn to cope with because, in the cold light of morning and in the hazy moments before sleep, there is at last no choice but to deal with the darkness.

AMD: No Cause, No Cure—Yet

¶ There are thought to be about ten million Americans who are victims of age-related macular degeneration. The number of those with the severest form grows by an estimated two hundred thousand each year. And indeed, because it is age related and was originally called senile macular degeneration, the graying of the very large baby-boomer generation suggests that by the year 2020 the number of Americans who have been hit with AMD will be staggering. Age-related macular degeneration is a growth industry.

The question is, What did all of us do to deserve AMD? The answer, the frustrating answer, is that there isn't any answer.

Thus far no genetic factor has been identified. In my own family, for example, so far as I know there is no evidence of AMD back for two or three generations. Too much reading? Too much sunlight? There seems to be no persuasive indication that it is either, although there is some thought that it may well be prudent to wear sunglasses that minimize ultra-violet rays.

There are two kinds of AMD. The so-called wet AMD

results from hemorrhaging in the eyeball, leakages of blood or a couple of other liquids, which cause the macula to become swollen. The macula is that part of the retina that gives us our central vision. The other, or dry, version of AMD affects far more people and, alas, is very nearly impossible to do anything about. In dry macular degeneration, the macula atrophies or thins over a period of time, often a very long period of time. This is a layman's interpretation of the complicated and very minute physiological goings-on in the eyeball, but I think it's a reasonably accurate picture.

Since wet AMD, which is what I have, somehow involves blood and blood vessels, my own hunch, and not mine alone, has been to point the finger at high blood pressure. I had a very slight but identifiable heart attack about six years ago, and a mild stroke, luckily with almost no lasting impairments, in 1996. I've been taking medication for high blood pressure for several years now, and it seems not unreasonable to me that my pressure, which remains moderately high even with medication and careful diet, could have been a factor in the arrival of AMD in my left eye ten years ago and again, more devastatingly, in the fall of 1999, in my right.

Since there is no absolutely agreed-on cause, there is apparently nothing you can do to forestall the onset of AMD. Some ophthalmologists, including my own, Dr. Jay Gross, recommend vitamins; in my case, a multi-vitamin rich in zinc each morning and another multi at night. There are those who also recommend a substance called lutein, which occurs naturally in spinach among other greens, as a potential preventative and possibly also as a stabilizer after AMD has hit. But so far as I know

there is no solid clinical evidence yet that vitamins are significantly helpful.

There being no agreement on what precipitates AMD, we are also pretty much out of luck once it has attacked us. Efforts to stop the further decay of vision by using laser shots and other techniques are having generally positive results, just as the laser shots a decade ago stabilized what was left of the vision in my left eye.

Another new approach, only recently approved by the U.S. Food and Drug Administration (FDA), is the Visudyne procedure. Before the FDA approval was given in the spring of 2000, I underwent the procedure as an experimental patient. My retinal surgeon, Dr. Thomas Hanscom, was one of the surgeons in the country participating in a testing under the auspices of the Ciba drug firm. I was the first in Hanscom's office to undergo the procedure.

In one of the examination rooms, now crowded with technicians from Ciba and a laser firm, along with Hanscom and his assistants, I sat in the usual chair and was fitted with an IV linked to a shiny electric pump. The idea was to inject a dye the color and consistency of split pea soup into my vein, wait five minutes and then train a low-power laser beam on my right eye for a few seconds, activating the photosensitive dye.

Things got off to a dramatic start because the pump experienced a small blockage, a mechanical occlusion, which set off a whooping beep like those you hear on ambulances and TV medical shows. Adjustments were made and the pump started again, only to occlude again and beep again. I somehow stayed not only calm but amused by this going-on, although I sensed not alarm

43

but a small degree of exasperation in the good doctor. But the third time was the charm, and the green dye went coursing through my veins with the eyeball as the principal destination. After a precise countdown, while I waited with my chin in the familiar eye-patients' stirrup, the laser light went on for a few seconds, the IV was removed, and I went home to await the results three months later. I was charged to avoid all sunlight for at least twenty-four hours. The dye is photosensitive, and in direct sunlight it can produce a kind of very painful sunburn that works out from the inside rather than the usual way. Thereafter, Dr. Hanscom told me to call him immediately with any changes in my vision. There were none, and three months later I went back for the by now familiar picture-taking of the eyeball after it had been suffused with a fluorescein dye. Hanscom inspected the photographs the next day and reported the relatively good news that there was no sign of any new leakage. The condition of the macula was stabilized, and this was the hoped-for result of the procedure.

In the meantime, the FDA has approved the Visudyne procedure for general use. It is quite expensive and for some patients it is recommended to be used every three months. At that time, Dr. Hanscom did not recommend further treatment, since the macula seemed to be stabilized.

In a limited number of cases, some patients reported improvement in their vision, although neither Ciba, the company that makes the dye, or the doctors themselves offer restoration of sight as even a claim.

There is understandably a lot of wishful thinking among AMD patients for some degree, any degree, of

restoration. There are testimonies in behalf of other experimental techniques, although retinal experts are generally skeptical of such reports.

Like cancer, AMD has given rise to alternative treatments, although most have lacked the large-scale clinical trials any procedures require before they can be approved by the FDA. A friend of mine underwent a procedure called plasmapheresis, in which the blood is "washed" clear of impurities, a technique used with some success on arthritis victims. This approach was advanced by physicians in Florida rather than by ophthalmologists or retinal surgeons, who are dubious about its efficacy. But my friend reported enough improvement in her vision that she drives again, albeit only by daylight.

There have been experiments as well with high voltage protons at Loma Linda University, with some positive testimonies from those who have been treated. But again the professionals in AMD work point to the absence of large-scale trials and the presence of ophthalmologists to measure and verify the results.

Yet another recent technique involves injecting a substance directly into the eyeball at intervals over the course of a year. Another friend of mine tells me that the treatment stopped the leakage in the affected eye and he notes some improvement in his vision. He is receiving this treatment at the renowned Jules Stein Eye Clinic at UCLA.

Enthusiastic personal testimonies are difficult to evaluate because there are not only the two basic forms of AMD, there are other visual conditions that may be erroneously described as AMD and which may resemble

macular degeneration, but which may actually be treatable.

A great deal of experimental work is being done at Johns Hopkins and elsewhere in the particular hope of finding ways of restoring vision lost to AMD. These efforts involve microsurgery and even cell relocation. There are even efforts to create an artificial eye which would transmit electrical impulses to receptor cells in the brain—paralleling the way human vision actually works. It seems likely, however, that none of these efforts are apt to bear fruit in either the near or mid term.

For the moment, all any of us can do is eat and live thoughtfully, quickly report any significant changes in what we can or can't see, and wish the researchers Godspeed in their searches.

George

¶ I suspect that for each of us who has been suddenly afflicted by AMD the first reaction of dismay is followed by powerful feelings of gratitude that we are not totally blind. We may be legally blind, but we are not, as I wrote to friends, blind-blind. There is much that is left to us to see, however fuzzily.

The further reaction, and it too is extremely powerful, is a freshened awareness of the condition of those who are totally blind, or nearly so. It is profoundly unsettling to think of those blind from birth who cannot envision red or blue, or those blinded later in life who have to relearn how to live. Within our own small captivity of partial darkness, it is impossible not to think of those who cannot imagine a snow-capped mountain, or the face of someone you love. But this awareness brings an immense admiration for all that the unsighted are able to do. To see someone crossing a busy intersection alone, white cane tapping, is to feel a tremulous combination of alarm and admiration, combined with a fervent hope that drivers will perform well.

I have found myself thinking a lot in recent days

about my friend, the great jazz pianist George Shearing, who has been blind since birth but who in his eighties is still entertaining large and enthusiastic audiences. Most recently he concluded a triumphant six-month tour of his homeland, Britain, and flew on to Australia to a splendid reception there. In the last few years, George and I have mostly been in touch via Christmas cards. But from a time when he lived in North Hollywood, we had frequent contacts, introduced by Leonard Feather, the Los Angeles Times jazz critic who had been Shearing's sponsor when he came to make his career in the United States. Feather had known his fellow Englishman since George was a teenaged accordionist playing in the dance band of the Royal National Institution for the Blind. "Our theme song," Shearing told me later, "was 'I'll Be Seeing You.'"

That was my first inkling that a jokey attitude toward life was a kind of first line of defense for Shearing and his friends against self-pity or, probably more important, the pity of others, however genuine and well-meant. George remembered one night, just before the curtain went up on a performance by the band, when one of the musicians dropped a glass eye. "Here we were," Shearing said, "all of us blind or partially sighted players on our hands and knees, scrabbling around on the bandstand trying to find the eye before somebody stepped on it."

In his early days in America, Shearing was working as an intermission pianist at one of the jazz clubs along Fifty-second Street in New York. A few doors along the street, Shearing's great idol, Art Tatum, a fellow blind pianist, was also playing intermission piano.

Unfortunately, their schedules did not coincide so that Shearing was never able to go by and meet Tatum. But one night their schedules shifted and Feather escorted George to Tatum. Tatum, whose dazzlingly fluid arpeggios have never been surpassed, was deeply paranoid and would drink only bottles of beer that he uncapped himself at the piano.

George blurted out his admiration, saying he used to save his sixpences to buy Tatum's records and telling Tatum how much his style, what Shearing called the locked hands style, had influenced his own playing. Tatum heard him out and then said matter of factly, "That's wonderful, boy; you gonna buy me a beer?" Shearing said he'd never quite gotten over the jolt of that response.

Shearing later moved to North Hollywood. Feather was by then living there as well and writing for the *Times*. One night I wrote a piece about Shearing when he was appearing at the drummer Shelly Manne's The Manne Hole on Cahuenga in Hollywood.

Shearing would turn on the overhead light above the piano to signal the start of a set. After the first set, he turned off the light but then turned it on again for the photographer's benefit. "Don't get excited," Shearing told the crowd; "I'm not playing again just yet. I'm having my picture taken for *Braille Magazine*."

Shearing has always used humor as an entertainer (often supremely corny jokes). But I came to feel that the humor was not only a defense against pity, but a barrier of sorts against the fears that must inevitably be part of the cost of living in a sightless world. In later years, Feather told me, George had made plans to sail

back to England on one of the Queens for a visit home, but that at the last minute he changed his mind and left the ship, unwilling to handle the claustrophobia that went with the idea of having to cope with an emergency in unfamiliar surroundings.

In his North Hollywood days I enticed George to lunch at the Smoke House not far away in Burbank, and picked him up. As soon as I pulled away from the curb, George said, "At this next intersection, the cars come barreling past. Turn left, but very carefully." He guided me all the way to the Smoke House parking lot so expertly you'd have said he saw it all the way.

At the end of lunch the waiter brought coffee but I didn't spot the sugar and said I'd get him back. George took my hand and slapped it on the sugar bowl, which was cunningly placed behind a kind of copper fence at the base of the table lamp. "Better start on those Braille lessons," George said, a remark that sounds curiously prophetic now. George, as I knew, had card files in Braille on the disc jockeys and other musical figures in every city where he appeared, call letters, phone numbers, the names of wives and sweethearts.

I began to feel there was very little that George did not have under control.

But years later, after Shearing had moved back to New York and remarried, I was in Chicago for a meeting and discovered that George was appearing at a supper club on Wacker Drive. I hadn't talked with him in some time and I went by after a dinner session. Between sets he came to my table and we had a drink (his was coffee). As we chatted, a waitress came by and put a business card in front of George. "Got a good customer at

table 43," she said, "and he'd love your autograph."
George said, "Got a pen, Chuck?" He took it and then
placed my hand atop his. "Sign my name," he said. I was
startled. I had come to think there was nothing he
couldn't handle.

"Chuck," George said, "I have absolutely no idea
what script looks like. Simply can't visualize it."

So I guided George's hand and wrote "George Shear-
ing." The man at table 43 has a unique small document.

I was simply thrust back, in an embarrassing way, to
the knowledge I had let slip for a moment that being
blind is not the same ever as not being blind, no matter
how skilled and ingenious the unsighted are at deploy-
ing the other senses to achieve a full and useful exist-
ence. Indeed, I am awed, and grateful to know what the
potentials are, even if the light should continue to fade.
In the meantime, the botherations of low vision are not
to be compared with not knowing what red looks like,
or a signature.

"Funny; You Don't Look Any Different"

¶ One of the peculiarities of being partially sighted is that, as a friend of mine remarked when I told him of my new status, "Funny; you don't look any different." And that's true; anyone encountering me confronts the same old face, unchanged in outward appearance. The difference is all inward: what I can and can't perceive through those same hazel eyes.

What to tell the world, or whether to tell the world, about my newly limited vision, is a curious and subtle question. To detail your affliction by macular degeneration, your inability to drive any more, or read without massive magnification feels, even as I am saying it, like a kind of inverted bragging, implying a request for sympathy and even pity, which in fact I haven't sought, don't really expect, and don't want. The sympathy, when I have to tell friends, is quickly and earnestly given, but whenever I can avoid it I prefer to.

The difficulty is that the need to reveal your vision condition is sometimes inescapable. I find that I have to reject or return the manuscripts, scripts, and bound galleys that still come to me with a request (which I would

often like to grant) for a dust jacket blurb or simply a recommendation to a publisher. In the same way, I still get any number of invitations to screenings of forthcoming films or television shows or documentaries emerging to face an indifferent world, and I have to explain that I can only see the screen large or small out of the corner of my eye. Things seen in sidelong glances are a poor substitute for what I have to call the real thing, not least because I can't read words on those screens, unless the main title is really, really large.

If I see myself in the mirror as an updated Headless Horseman, that is the way I see most people now, especially when they are more than four feet away. If they stand closer, a foot or so away, I can generally make them out, as I can stand with my nose virtually touching the mirror when I shave and perceive that I am I. Then again, not everyone can politely stand within a foot of me except at overcrowded cocktail parties, so that recognizing even old friends is an ongoing dilemma.

One night I was having drinks with some friends. I had to confess to the lovely woman sitting across from me that I couldn't see her facial features but that her lilting Alabama accent was as identifiable as a portrait. She leaned across the table and put her face within a few inches of mine. "Aha!" I said, "You have eyes, a nose, and a mouth, all right purty." We had a merry laugh. The truth is that you grow far more sensitive to the sound of voices and use them to your advantage, whether they are as deliciously deep South as hers or a less specific middle American sound.

On another occasion at a very large banquet on a

dimly lit sound stage at the Fox studio, I had hell's own time recognizing anybody even though most of those present had been colleagues at the *Los Angeles Times*. Often after a pause I could recognize a voice or a general stance. But others had to tell me who they were, for which I was as always very grateful.

After a number of such encounters it occurred to me that it might be helpful to have a lapel pin that somehow identified my vision problem and encouraged people to remind me who they were. In fact, I have had a graphic designer I know sketch such a pin. It features a rather stylized eye with a pattern of dots in lieu of the iris, thus symbolizing the somewhat sieve-like nature of my sight. Encircling the eye are the words "Limited Vision. Please Say Your Name." I plan to have a few dozen made up and see if there is any demand for them. My thought would be to make the pins available free of charge.

Banquets and other public events are one kind of challenge, chance encounters are another. Sometimes at restaurants old pals stride by crying, "Hey, Chuck," as they hurry along. Unless I've got Peg or another spotter with me, I have no idea who the greeter was. I sometimes worry that my friends suspect I am getting snobbish or am in the early stages of forgetfulness. At my age, of course, there are times when you need an extra beat or two to come up with a name but at least in most cases you know whose name you can't come up with. These days I not only can't come up with the name, I can't place the face or see it. At that point, I wonder if I should let it be more generally known that I am not aloof but only a sight with sore eyes.

In questions of revealing your troubles or coping with them, other senses come to your rescue as they do in many matters. Hearing—specifically the sound of voices—is a great help now in identifying those faces I can't clearly see. I would not have said I could identify a lot of my acquaintances by voice alone, but it turns out that I can, and casual acquaintances as well as close pals. Memory is a help, too, not just of the voices but of height, weight, stance, mannerisms: what you might call silhouette memory.

You don't work as a journalist for fifty years without becoming a social animal, in the sense that I was out and about constantly, ricocheting in and out of people's lives, canvassing the arts from jazz to chamber music to ballet to print-making, and the other visual arts. The more I consider the range of friendships I acquired over those years, the more I think the lapel pin is a useful idea. It would be a help in those clean, well-lighted places Hemingway described; it would be a godsend in those under-lit and overcrowded gatherings. But in the matter of revealing my changed visual status, as in everything else related to AMD, you have to play it by eye.

Edging Back to Work

¶ In a real sense, my life did not change drastically after the assault by AMD. I arose and, in due course, brushed my teeth (a slight relearning experience involved there). I brought in and unwrapped the two newspapers, tossing away the ad supplements but leaving the good stuff for Peg to sort out.

Thanks to my rough and ready touch typing ability, I've been able to spend many of my mornings keeping up a sizeable correspondence, and also these random notes about life with AMD. What I hadn't done for many weeks was a work of professional journalism, an assignment. Then an editor at *Architectural Digest* phoned and asked me to do a kind of emergency piece on a house that Bing Crosby built and that burned in 1943. Why it was an emergency I don't know; these things happen in magazine journalism.

It was, to coin a phrase, a cold trail, the house built more than sixty years ago, destroyed fifty-seven years ago. The magazine had gathered up what research its people could find. Peg was able to find a bit more at the UCLA library and I set to work, with an unusual degree of nervousness, I must say.

It was essentially a kind of fast rewrite, only eight hundred words and no more than a thousand wanted. But organizing a piece is a skill that has to be kept in shape like biceps, or so I came to think. I thought back to the first days I was writing at Life and trying to convey much in little, under the stern eye of copy editor Joe Kastner. Joe, a burly, sad-eyed, red-haired man who wore Murray space shoes, oversaw every word that went into Life (and there were thousands of them even though it was a picture magazine). My long-time office mate, David Snell, once rewrote a famous quatrain and concluded that it didn't matter whether you won or lost, but how your writing struck Kastner. Joe was a tireless worker, seeming almost always to be at the edge of exhaustion, writing his endless emendations in soft pencil on flimsy yellow sheets from the copy room. I learned almost everything I know about writing tightly but gracefully from Joe's editing. He taught me that there was absolutely nothing that could not be said more briefly. Now, thinking about the Crosby house, I saw myself in 1954 sitting in room 31-11 of the old Time-Life building on Rockefeller Plaza, doing twenty drafts of the lead text block on a color page of an accident whose details I have long since forgotten. The text got shorter and shorter until it was within range of the layout's specification.

Now here I was again, doing three drafts not for length but simply to marshal the facts in the proper order to achieve a small emotional effect even in so brief a space. The old skill, as I thought of it, manifested itself in a lead sentence that did not change from first version to last. But setting Bing's bio to 1936 (not too much,

the editor had said), describing the house and such details as we knew or could surmise from some photographs, introducing wife Dixie and the four sons, and setting up the drama of the Christmas tree fire that took the house with it, that was the trick.

The doing was harder than I thought it would be, and the tricky part was somehow carrying all the details in my head, because I couldn't see the notes and even the rough drafts were difficult to see intact on the magnifying machine. But at last I dictated the final version to Peg, who doubled as transcriber and editor, keeping the sequence of ideas clear in my mind and coherent.

When we finished in early afternoon and printed out a fine copy, it seemed right to me and I was not so much pleased as relieved. We sent the copy to the *Digest* by e-mail, and what seemed like only minutes later, the editor, Mary Ore, called to say that she liked it a lot; it hit, as she said, all the right notes.

It was beyond doubt a kind of milestone as I worked my way through the perils and detours of AMD. It is clear that research projects are going to be tough. Working from various text sources with limited vision is difficult, and self-editing is much harder now than it used to be. But I tell myself, evaluating my work as objectively as I can, that the basic writing and organizing skills I've been honing, or at least using, for sixty years are still there, in need of exercise but detectable. The fact is that I felt like an aging fighter, trying to make a comeback, and finding he can do it, providing the opponent isn't too tough.

Pursuing the Arts

¶ It requires more than an assault by macular degeneration to demolish a lifetime's affection for the arts in all their infinite variety. As with everything else, it is no use kidding yourself that the perceiving of art is undiminished. But the disappointments and frustrations of culture received with limited vision may well equal or even outweigh the pleasures. Only the pleasures of music remain unaffected and undiminished. Enjoying the other arts post-AMD requires a certain amount of adjustment.

We took an old *Life* magazine buddy now living in Wales to the Getty, that shining white colossus high atop one of L.A.'s crumbling hills, only ten minutes from our house. Grandeur is a quantity that sore eyes and limited vision can still see, and the Getty Museum offers all the grandeur that man, plus a few billion dollars, can create. It is an almost Escher-like collage of walls, spaces, stairs and vistas, including sudden vertiginous views seen through floor-to-ceiling glass as you turn a corner or pass through a door, all to the unnerving of the devout acrophobe. There is no doubt that J. Paul Getty's oil fortune was well spent.

But the galleries themselves, with their vast collections of sculptures, portraits, paintings, illuminations, and other works of art, leave the AMD person impressed if not awed, and at the same time frustrated because a lot of it is worth seeing but not wholly seeable. The antiquities declare themselves antiquities quickly enough. One can identify some of the more familiar paintings, depending on how much of a connoisseur one had been before. But no small part of the disappointment is that I could not read any of the identifications, and I was grateful to have Peg at my side to give me at least the highlights: artist, title, year. In the case of portraits, which I have always dearly loved, I have to get close enough to make out the face. Then, for example, a young Dutch woman in a mob cap, with a rather mocking and mysterious grin, smiles at me provocatively across the centuries.

But for the most part my awareness is of what I can't see, rather than what I can. The heroic paintings on mythic themes, the rape of one maiden or another, the heavenly visitations to grateful saints, I find boring as ever. Yet other paintings reach out to me, like the portrait of an unknown man, said to be courtier, astrologer, or alchemist.

As with movies and television, I have to look sideways at paintings and sculptures, and while in my peripheral vision I can glimpse the whole painting or the whole carving, the image is blurry, and although the color is present, a great deal of detail is lost. Seurat and other pointillists seem to have lost the point and are using flat paint only. Sculpture in my sidelong glances appears curiously rubbery.

I am not nearly enough of an art patron to judge the Getty collection, though I keep hearing that the elitists regard it with condescending indifference, whatever they think of architect Richard Meier's achievement with the Getty as an environment. But I do conclude that visiting collections with which I am more familiar—the Tate, the National Gallery, the Museum of Modern Art, the Metropolitan—might well be more pleasing, a visit to old friends, however dimly seen.

Theater is a mixed blessing. We went to see a new play, "Metamorphoses," a remarkably innovative presentation of ancient myths enacted around and splashing through a very large wading pool constructed on stage at the Mark Taper Forum in Los Angeles. The disappointment in this case was that the text was enriched with all kinds of visual business, often pretty funny to judge from the reaction of the audience, but which I could not see, despite the fact that no seat at the Taper is far from the stage. I had the feeling I had caught about half the play, and I wished it were more.

A bit later, on a quick visit to New York, we went to see a revival of Meredith Willson's "The Music Man." From our $65 seats high in the balcony, the cast appeared to be midgets. Here, as I think in visits to art galleries, memory became a large part of the pleasure. The musical, with Willson's simple and melodic ballads and its rousing major anthem, "Seventy-six Trombones," was a rather tearful journey to a fondly remembered past. Professor Hill was not Robert Preston and Marian the Librarian was not Barbara Cook or Shirley Jones, but the corny comedy was intact and those innumerable trombones as thrilling as ever. I expect we will continue

61

to go to the theater, most eagerly to revivals where the text or music will be evocative—old and admired friends seen, or at least heard, again. Music, of course, is the least compromised of all the forms of art, and I cherish it in all its modes with new appreciation. I have found fresh delight in the fairly large collection of LPs and CDs we have accumulated over the years.

As I've said before, movies and television are problematical. The greatest casualty for me is the foreign film, which I have loved obsessively ever since my first viewing of "Children of Paradise" and "Open City." The subtitles, however, are now an indecipherable garble at the bottom of the screen.

I think the last subtitled work I've seen was Pedro Almodovar's bizarrely sexy but very moving "All About My Mother," which we watched on a cassette at home. Peg bravely read the subtitles, explicitnesses and all, to me, blushing furiously all the while.

I find that the television I watch now tends to be programs I can listen to without having to see. There is still pleasure in looking at old movies again. On recent nights I watched Billy Wilder's "The Apartment" and the Jack Lemmon-Walter Matthau "The Odd Couple," both deliciously verbal films, but with images worth cocking an eye for along the way.

It is true, indeed, that memory is newly important to me in many ways, as in identifying friends by their voices, but in a real if subtler sense memory is more than ever a key to the arts. The pleasures of culture are very often remembered pleasures, pleasures recalled in sound and impaired but evocative images. Painfully, it is the new cultural experiences—new TV, new paintings,

new plays, new films—that are diminished by one's damaged vision. I am the more grateful that music continues to have charm as ever it did.

As Time Goes By

¶ Time goes by fast whether or not you are having a swell time. I realized rather suddenly that it had been a full year since Dr. Gross had given me the gloomy news about my vision, and Dr. Hanscom had identified macular degeneration as the villain. So it had been a year of learning to adjust to a new reality, a time of discoveries more often positive than negative in the context of my new state, but also, I have to say in candor, a time of angst and considerable frustration.

Over the first nine months, the periodic examinations of my right eyeball by Dr. Hanscom using a photosensitive dye indicated that the leakage had stopped and no further change in the eyeball was evident. That was very good news.

The only real homespun index I have of how the eye is doing is how much magnification I need on my machine to be able to read the body type of my two newspapers. There is no actual scale on the machine—it would be a significantly valuable addition if there were one—so I am only guessing. But I began to feel that I was requiring more magnification, revealed because I

could get fewer words on the monitor and was consequently shifting the reading material back and forth more frequently. The machine, valuable as it is, had become increasingly tiresome to use.

It seemed to me to be time for another checkup and I made an appointment at the Center for the Partially Sighted, where I had been examined soon after my visit to Dr. Hanscom at the start of October 1999, and where I was also interviewed so closely about depression and dismay. A nice young optometrist tested me thoroughly and concluded that the vision in the right eye was now 20/400, a significant drop from the 20/200 Dr. Gross had reported a year earlier. I quickly made an appointment with Dr. Hanscom, who took new pictures and indeed found traces of new leakage at the edge of the macula. Laser shots were still too dangerous to attempt, he said, but he recommended another of the Visudyne treatments I had had experimentally the previous December. The event was a good deal more routine this time; the dye pump worked smoothly and the whole injection took less than a quarter-hour. Thereafter, if there were no dramatic changes in my vision for better or worse, I would go back for a check-up in three months.

In fact, the slight loss of vision is not dramatic and not deeply worrying, depending on what the continuing check-ups reveal. The degree of magnification I need is my one easily discernible change and in all the doings of my daily life, walking, riding in cars, dining out, life goes on as it has, no more difficult, but with the lingering anxiety, like the background hum on a stereo, always there.

One of the casualties of my new state has been that my handwriting has gone to hell. I do most of what writing I do, like signing checks, beneath the magnifying machine. If I am addressing an envelope, as I do from time to time, the address done under the machine tends to scrunch up into a tight ball, as if I were trying to get it on the back of a small stamp. My lines tend to swoop up and down and my autograph resembles a bar check signed by a lush about three o'clock in the morning. When we leased a new car (how strange I felt to be buying a car I would never drive) I had to sign my name more than a dozen times—four times on one form. As I went along my signature came more and more to resemble a dying squibble on an EKG machine. My regret about the handwriting is that I always felt letters of condolence should be handwritten. I really can't manage that these days. And yet I am at that age when condolences seem to multiply. I have to hope my friends understand.

Another sizable if relatively unimportant aspect of my sight troubles is trying to find things. I make some attempt to remember where I have set things down, but more often than not either the things have moved by their own malignant will, or, a little more probably, they are hidden in plain sight. I have a favorite ball-point pen which is usually out of my possession three weeks out of four, to be rediscovered in a pocket or pair of pants I never wear, or a shirt which has somehow got into the laundry. Among my wife's innumerable new chores, helping me find what I can't has become a high priority.

I suppose the greatest enjoyment and consolation of limited vision is unlimited listening. What I find

interesting as a book-listener is that it seems to me I get more out of a text listening to it than I used to reading it word for word. Somehow the mind's eye sees very clearly indeed. I am for example now hearing Patrick O'Brien's Aubrey-Maturin sea series for the third time. It seems more vivid than ever before.

One of the great discoveries of my post-AMD days is what fine support services exist for the partially sighted as well as for the totally blind. Our numbers are thought to be growing with sad rapidity thanks in largest part to the prevalence of diabetes among the middle aged and elderly, and because of the increasing incidence of AMD and other conditions. Henry Grunwald has written in Twilight about the services of the Lighthouse for the Blind in New York. The Braille Institute in Los Angeles is equally useful, with classes to help the blind learn to live independently among its many offerings, and is the local lending library for the recorded books produced by the Library of Congress. I have had some very useful consultations and lectures at Braille, and it also has a complete array of the various magnifying devices and other equipment for all of the visually impaired.

On that subject, I must say, that one of the most delightful acquisitions I've made is a talking watch, which one of my daughters gave me for my birthday. It not only tells me the time in a cheerful chirpy voice, it will toll the hours if I want it to, or wake me up with a cock crow. My next acquisition, equally invaluable, was a talking scale found at the Braille Institute, which announces my weight in much the same female voice as that which tells the time and which does not comment adversely when I have risen a pound or two. On the

other hand, she never applauds when I have fought back my weight a pound or two, rare as that is. I also have a talking alarm clock.

I keep thinking that I have my new world pretty well under control, generally speaking—until, that is, I visit Beverly Hills, Westwood, Santa Monica, or even downtown Los Angeles, and start walking. This can be a very scary experience. In Beverly Hills, where no one walks if they can help it, there are fewer pedestrians to tell you that it is safe to cross the street. As with movies and television I have to see with peripheral glances and for some reason stop lights are hard to make out, especially when bright sunlight is behind them. You do get shameless, or perhaps just bold, about asking strangers whether it is OK to cross, and more than once I have had to wait a light or two until another walker came along.

One recent week, with time to kill before a luncheon on Sunset Boulevard, I decided to walk from Wilshire Boulevard in Beverly Hills. For one thing, it was a good deal further afoot than it seemed from the comfort of an air-conditioned car. It also involved crossing innumerable streets. By the time I had reached the restaurant, a half-hour late for my engagement, I was drenched in two kinds of sweat: exhaustion and anxiety. I must say that at the end I gained a lot of confidence about crossing streets, but it is an activity that I had not previously thought could be so thrilling.

By now I've had many months of dealing with the challenges macular degeneration throws at you. The subtlest problems are the trickiest—acknowledging the slow build-up of frustration, accommodating to that almost-

daily moment before waking when you imagine you can see as ever, and awake to find you can't. My salvation is that I can still write. (I would make typing a mandatory course in all high schools, not least because the skill is central in the world of computers.)

So far as I am concerned, typing has made the difference between being able to write a lot or being, in a metaphorical sense, voiceless. As Mehitable the cat was always saying in Don Marquis's "archy and mehitabel," "Expression is the need of my soul." Mine, too. I am grateful to be able to share the experience of limited vision with those who perhaps cannot imagine what it is like, or who on the other hand may know all too well and are glad to be reminded that they are not alone.

Helpful Sources

American Macular Degeneration Foundation
P.O. Box 515
Northampton, MA 01061-0515
1-888-MACULAR
www.macular.org
The AMDF publishes a quarterly newsletter, *In the Spotlight*, available for a contribution of $25.

Braille Institute
741 North Vermont Ave.
Los Angeles, CA 90029
(323) 663-1111
www.brailleinstitute.org

Center for the Partially Sighted
12301 Wilshire Blvd., Suite 600
Los Angeles, CA 90025
(310) 458-3501
www.low-vision.org

Lighthouse for the Blind
111 E. 59th St.
New York, NY 10022
(800) 829-9200
www.lighthouse.org

Macular Degeneration Research
A program of the American Health Assistance Foundation
15825 Shady Grove Road, Suite 140
Rockville, MD 200850
(800) 437-2423
www.ahaf.org
Macular Degeneration Research News is published quarterly.